SKETCH THIS

SKETCHED BY:

new seasons®
a division of Publications International, Ltd.

CAUTION:

YOU ARE ABOUT TO GET CREATIVE. YOU MAY START TO DO THINGS DIFFERENTLY IN HERE. YOU WILL LEARN THINGS ABOUT YOURSELF AND HAVE FUN IN THE PROCESS. BE WARNED— YOU MAY START FINDING INSPIRATION EVERYWHERE. AND THESE SYMPTOMS WILL NOT GO AWAY.

Draw on this page when you're happy.

Go to the nearest window, and draw what you see.

Write down all the things you wanted to say today but didn't.

~~You can~~ make ~~one pound of peanut butter from 720 peanuts.~~ This page ~~is just one of 81,430 pieces of paper that came from one average tree.~~ ~~Babies typically begin to~~ speak ~~at one year. Armadillos are able~~ to ~~walk underwater.~~ You can form the number 12,345,678,987,654,321 by multiplying 111,111,111 by 111,111,111. The total revenue generated by billboards in Times Square, which has more ads per square foot than anywhere else in the United States, is sixty-nine million dollars per year. February is National Mend a Broken Heart Month. Dreaming of being chased is by far the most commonly reported dream. One bat can eat one thousand insects in an hour. Green Thunder is a Welsh cheese that is infused with garlic and green herbs. In Chicago, serving whisky to a dog is against the law. The formal name for a group of porcupines is a prickle. Aztec Indians in the sixteenth century used garlands of popped maize as a decoration in ceremonial dances as a symbol of goodwill and peace. Fairyflies are tiny wasps that are cited as the smallest of all insects. On several occasions, Cleopatra dressed as the goddess Isis to play upon the common belief that Egyptian kings and queens were the incarnations of gods. The bones in whalebone corsets were actually baleen—plates of combs in the jawbones of whales used to strain plankton from the water. Leo Tolstoy left all his possessions to the stump of a tree. The name Atlantis derives from Atlas, the Greek god who is said to have supported the world on his back. Unborn crocodiles make noises inside their eggs to alert their mother that it's time for them to hatch. The original name of the telephone was the harmonic telegraph. Golf balls were originally made of leather and stuffed with feathers. Men blink half as much as women do. The word robot is derived from the Czech word for slave. Spots on dice are called pips. A cucumber is considered a fruit, not a vegetable. The average snail lives six years. Babies are born without kneecaps. The Leaning Tower of Pisa has eight stories. Texas has a law that prevents people from carrying concealed ice-cream cones. The first toothbrush was developed in China in 1498 and featured bristles made of hog hair. The quickest way to wake a penguin is to step on its foot. A skin cell does not live for more than a day. Thomas Edison preferred to read in Braille, and he proposed to his wife in Morse code. Fish sometimes cough underwater. More car crashes happen on Saturday than on any other day. Traces of peanuts can be found in dynamite. There are pink dolphins in the Amazon River. Flies taste with their feet. The human body contains approximately four ounces of salt. Mosquitos have forty-seven teeth. Human beings are the only animals that cry emotional tears. Children grow faster during spring than any other season. The longest-living cells in the body are brain cells, which can live a human's entire lifetime. The Milky Way Galaxy is currently merging with a tiny dwarf galaxy. A typical lightning bolt is hotter than the surface of the sun. Objects weigh slightly less at the equator than at the poles. Mountain lions purr, hiss, scream, and snarl, but they cannot roar. Bees have five eyes.

Use a picture you've taken to sketch a landscape.

ART IS POWER.

—Henry Wadsworth Longfellow

finish the pattern.

Draw something operational.

Make a drawing using only circles.

The beautiful is always bizarre.

—Charles Baudelaire

Sketch a garden.

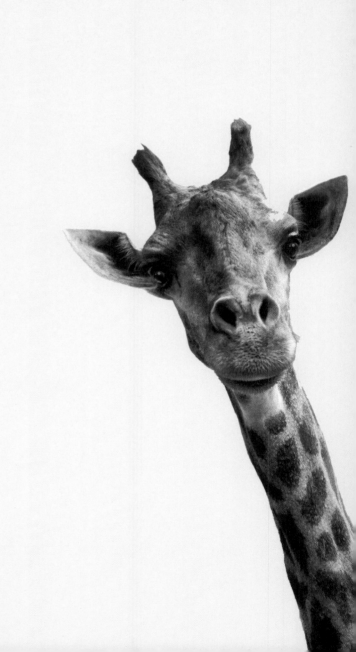

Make a design out of
tape of any kind.

TIC-TAC-TOE

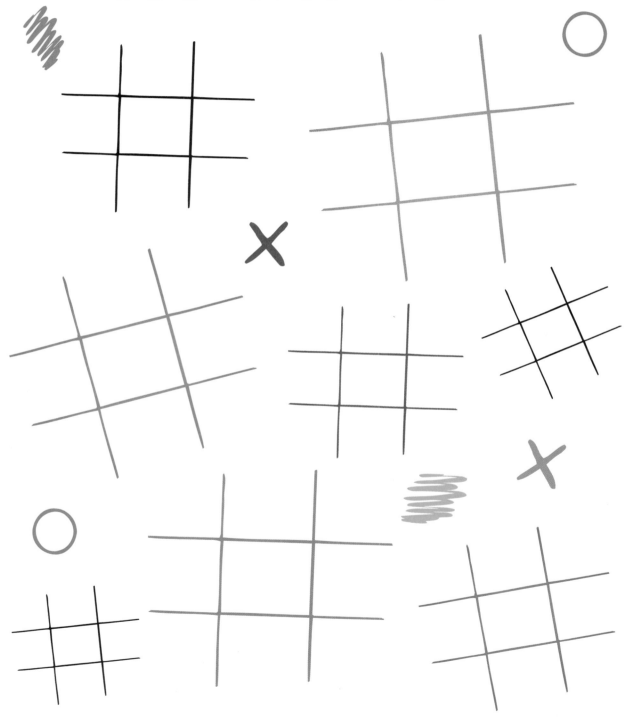

Draw a map of your neighborhood.

Style some hair.

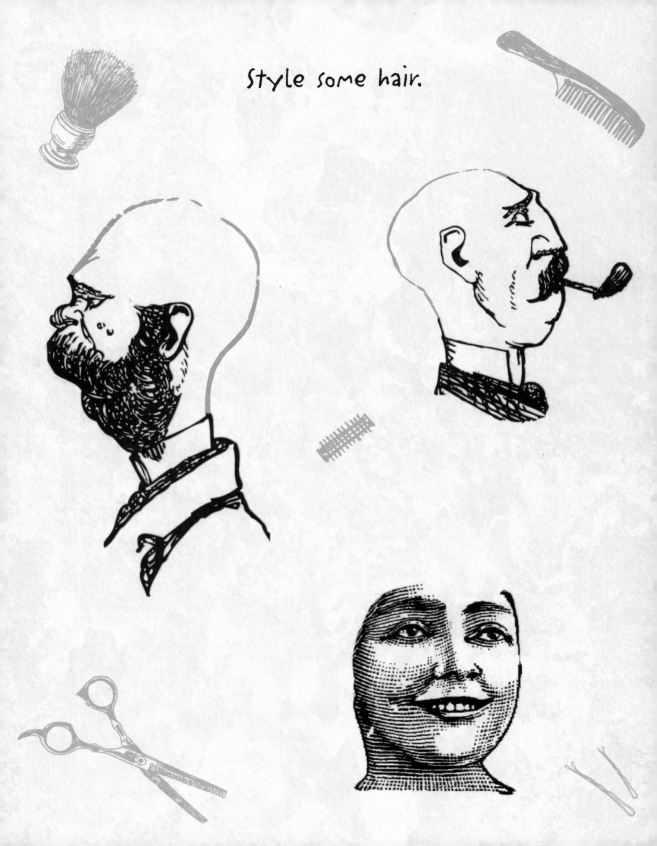

Draw something transitional.

Draw with crayons.

Draw yourself as a
SUPERHERO.

Art, like morality, begins with

drawing the line somewhere.

—G. K. CHESTERTON

Make a SKETCH for each letter.

A aspiration

B best friend

eccentricities

favorite family member

F

E

injury that hurt most

Together, they make a self-portrait.

cartoon character I invented

daydream destination

gathered trinkets

hang-out spot

job I want

K kudos I deserve

L longest car trip

O ocean(s) I've swum in

P pet(s)

S song stuck in my head

T tree(s) on my street

movie I love

novel I love

quarrel I regret

recipe I make often

unusual facial feature

vehicle(s) I own

weekend plans

ex or
former friend

yucky stuff

zorse, liger, beefalo:
my own mixed-up creature

Now draw a realistic
self-portrait.

I am currently...

...listening to

...reading

...watching

...enjoying

...wishing

Make rubbings.

ANT FARM

Guilty Pleasures

Draw a monument to something.

Look up. Sketch the sky today.

Sketch what you think of when
you hear the made-up word "gulfuntious."

Make a quilt out of magazine clippings.

I dream my painting

and I paint my dream.

—VINCENT VAN GOGH

Make a drawing without lifting your pencil.

Finish the rollercoaster.

Make some Graffiti!

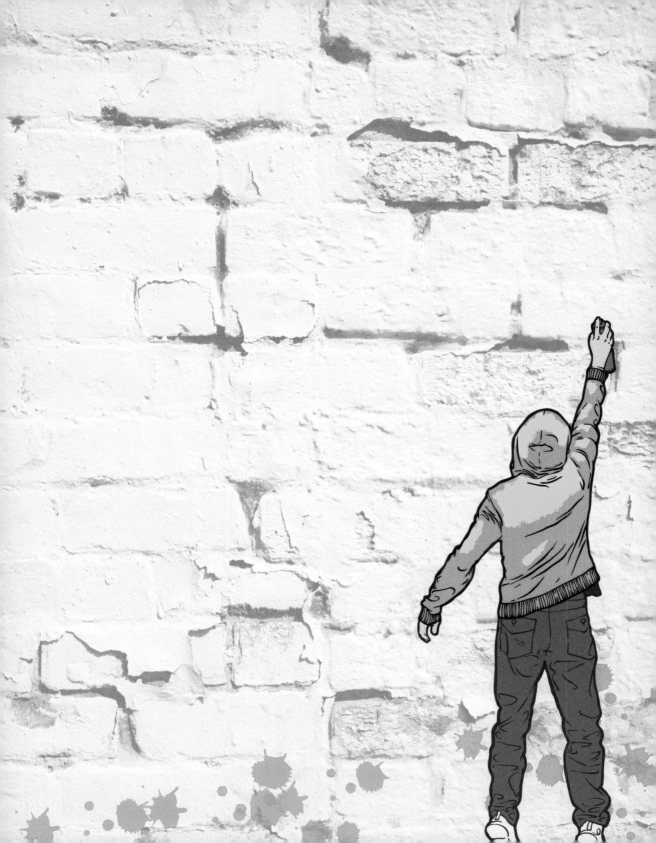

Draw clothes on these animals.

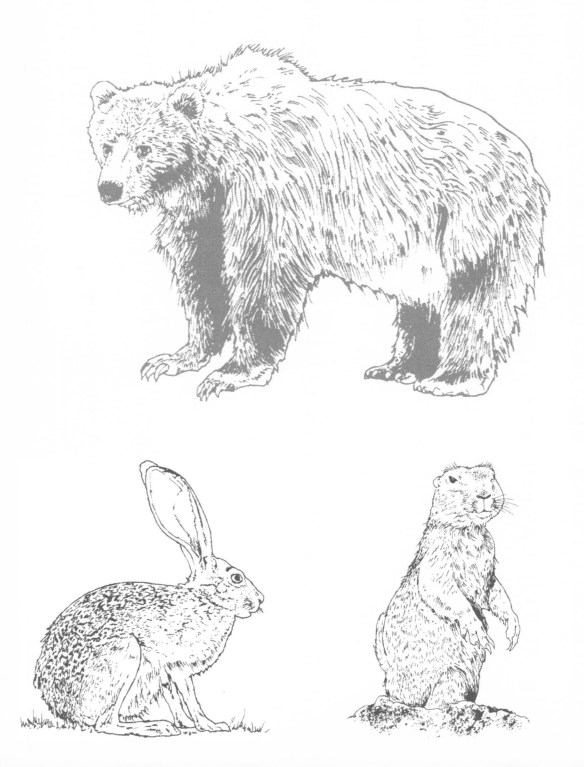

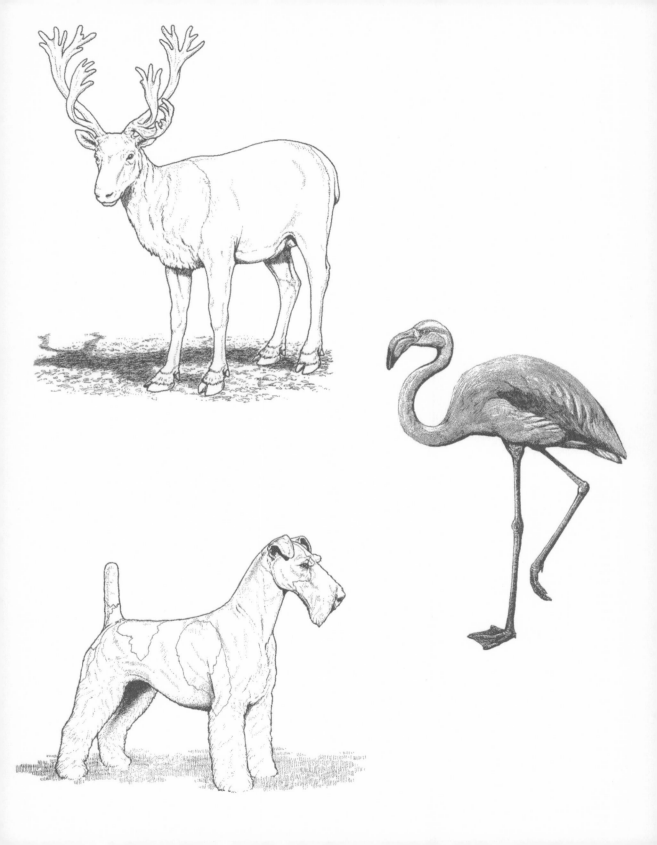

Invent an electronic device.

Make a drawing using only letters.

A life spent making mistakes is not only more honorable, but more useful than a life spent doing nothing.
—George Bernard Shaw

DRAW YOURSELF AS A MONSTER.

PLAY THE DOT GAME.

Draw something intelligent.

Trace your hand.

Trace your foot.

Paste a picture here.
Draw what's beyond it.

Draw the moods.

Happy Sad Tired Voracious

Shocked Upset Angry Hysterical

Content Superior Disgruntled Silly

Peevish Smug Snobby Languid

Suave Goofy Dorky Artistic

Smarmy Inventive Polite Nostalgic

Spunky Creepy Chipper Dramatic

Queasy Nervous Creative Nosy

Invent color names.

DRAW ON THIS PAGE WHEN YOU'RE MAD.

Draw this dog...

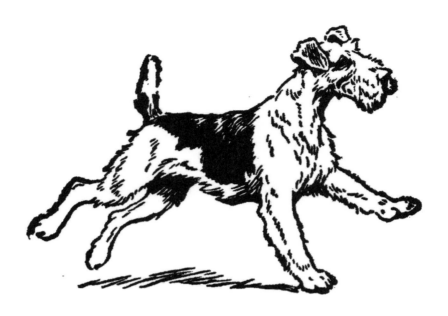

...upside down.

...with your eyes closed.

...without lifting your pencil.

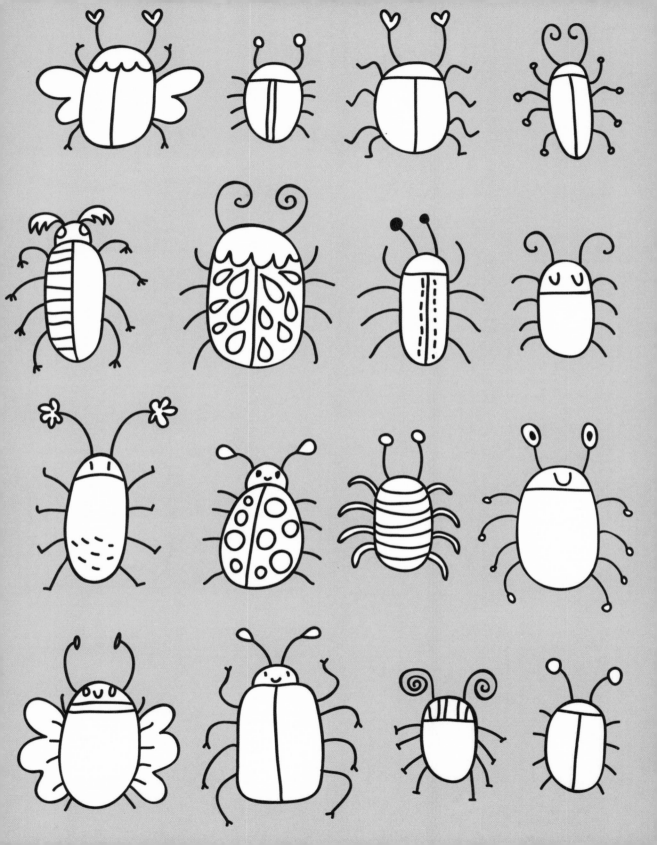

Words You Love

Words You Loathe

_____ _____

_____ _____

_____ _____

_____ _____

_____ _____

_____ _____

_____ _____

_____ _____

Spill things on these pages.

Make a code.

A B C D E

F G H I J

K L M N O

P Q R S T

U V W X Y Z

Write a message.

The artist must posses the courageous
soul that dares and defies.
—Kate Chopin

DREAM UP SOME NEW CREATURES.

Write your secrets here.

Illustrated Dictionary

BE INSPIRED.

Draw your favorite fictional character.

Tear out this page, and cut out these words.

car | beach | mom | dad | sister | brother | apple | tree | dog | cat | house

pencil | cup | drink | food | garbage | junk | coffee | sunglasses | shoes | ice

pants | coat | shirt | scissors | phone | knife | fork | spoon | headphones | fur

bicycle | truck | street | bird | plane | sky | paper | book | voice | hair | bag

face | hand | leg | insect | animal | fruit | language | luck | fun | picture

sculpture | mask | artist | brush | canvas | word | art | shape | subject | row

storm | blossom | flower | method | medium | collage | sweat | dinosaur

creature | origami | stamp | letter | glue | seat | bed | garden | park | river

sunset | moon | star | cloud | studio | window | soul | eye | mouth | pond

sea | neighborhood | underwear | sock | teeth | leash | fence | soup | word

recipe | poem | novel | story | horse | saddle | riot | theater | factory | wind

air | day | night | beautiful | absolute | giant | funny | glorious | welcome

super | sweet | grandiose | marvelous | abominable | stray | loose | gray | sick

delicious | pretty | red | yellow | blue | green | purple | orange | black | pink

white | smooth | round | big | little | tiny | strange | familiar | weird | heavy

intricate | young | old | crazy | new | bare | raw | crisp | cold | hot | all

none | is | go | see | do | run | walk | dance | sing | laugh | clap | jump

fall | spin | struggle | lose | call | shout | cheer | cough | sneeze | wheeze

sneer | smile | take | steal | grind | borrow | ride | ask | fly | read | make

give | love | look | see | grab | write | draw | sketch | paint | eat | wish

dazzle | surprise | work | let | could | would | should | sink | drive | want

sit | stand | stay | lay | feel | explore | play | erase | panic | will | can | hear

think | taste | smell | rather | I | I | I | you | you | you | me | me | me

him | her | his | our | your | their | they | them | we | us | my | it | a

a | a | the | the | the | one | other | on | in | out | of | of | of | to | to

to | from | around | along | where | under | around | behind | over | below

near | beside | far | down | up | through | soon | at | into | by | or | and

and | and | but | but | but | if | if | if | with | with | with | because | when

however | then | yet | ly | s | ed | ific | istic | ied | ies | s | er | est | ing | e

Use this side for your own words.

Now use them to make poetry.

Connect the dots.

Sketch what you think of when you hear the made-up word "spunktamonias."

Color is my daylong

obsession, joy, and torment.
—CLAUDE MONET

Draw something noteworthy.

Draw a map of a made-up place.

Design stamps. Paste in favorites that you find.

What's chasing this guy?

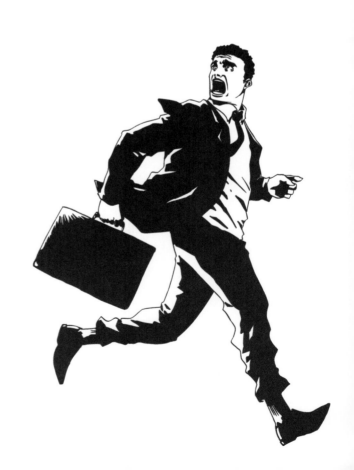

Paste items you found on the sidewalk on this page.

Sketch them on this page.

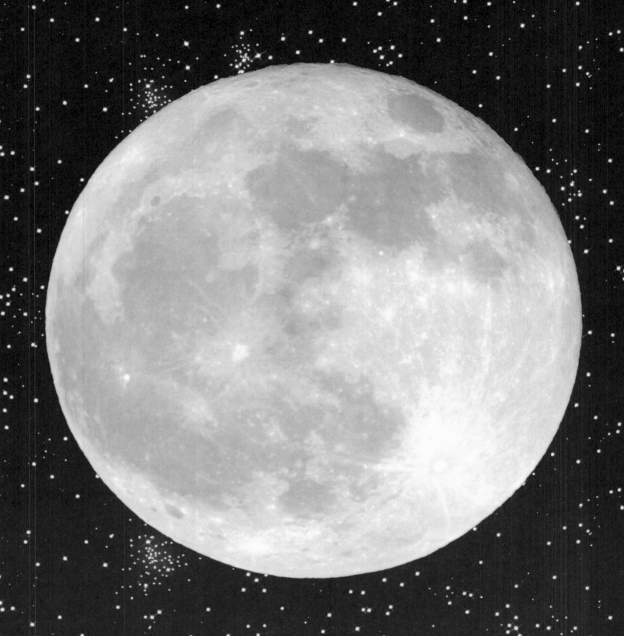

DRAW ON THE MOON
WHEN YOU CAN'T SLEEP.

Every artist was first an amateur.
—Ralph Waldo Emerson

Draw with charcoal.

COMPLETE THIS COMIC.

Make a note.

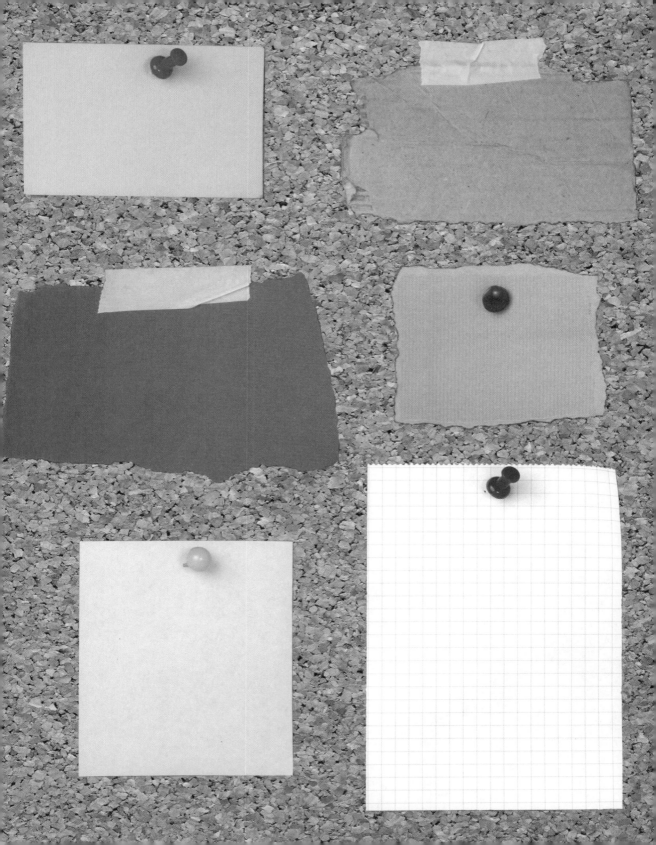

Dear Diary,

Design a 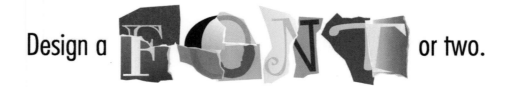 or two.

Connect the dots.

You don't make art out of good intentions.

—GUSTAVE FLAUBERT

Make a maze.

Open the nearest drawer, and sketch the contents.

Draw something inflammatory.

BROCK LEE

ANITA SANDWICH

LUKE N. GROSS

PEPE RONI

Collage A Ransom Note.

Draw what you think you'll look like in fifty years.